Letters for

From Lida – for David, Graham, Paul, Hallam and Vincent

*From Emma – for my Godchildren: Nicholas, Tom, Harry,
William, Edmund, Rachel and Vincent*

*Lida Lopes Cardozo joined David Kindersley's Workshop as an apprentice in 1976
and soon she became a partner in the Workshop. Later, they married, and had
three sons – Paul, Hallam and Vincent. Since David's death in 1995, Lida has run
the Workshop. In 1998 she married Graham Beck.*

*Emma Lloyd-Jones has been involved with design matters through book design
and an MA in Design Studies.
She first worked with Lida when she commissioned a sundial.*

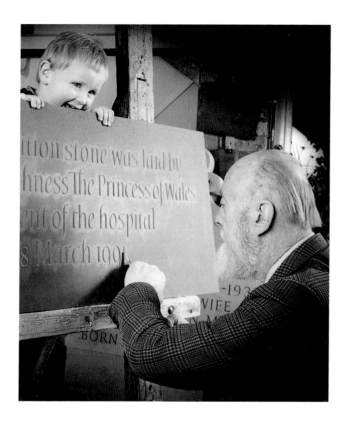

'The incisive moment is exactly when the act of creation is balanced between past experience and future vision.'

Lida Lopes Cardozo Kindersley

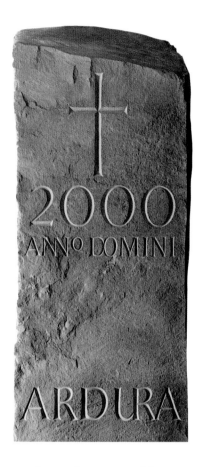

Letters for the Millennium

WHY WE CUT LETTERS IN STONE

Emma Lloyd-Jones & Lida Lopes Cardozo Kindersley

CARDOZO KINDERSLEY CAMBRIDGE 1999

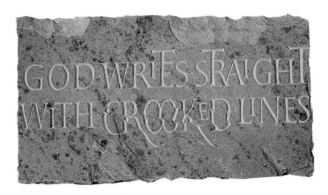

Cut in York stone for casting by The Wild Goose Studio, Ireland

Copyright © 1999 Emma Lloyd-Jones and Lida Lopes Cardozo Kindersley
British Library Cataloguing in Publication Data
ISBN 1 874426 11 2

Copies of this or any other Cardozo Kindersley publication are available from
The Cardozo Kindersley Workshop
152 Victoria Road, Cambridge CB4 3DZ, UK
Telephone 01223 362170

Designed by Emma Lloyd-Jones and Lida Lopes Cardozo Kindersley
using the series layout designed by Eiichi Kono.

Printed by BAS Printers Limited UK
Photographs by Simon Charlesworth (pages 49 and 62), Abigail Concannon (page
46 bottom), Julia Hedgecoe (page 65) Michael Manni Photographic (throughout),
Vic Seymour Photographic Services (page 55), and from the Workshop archives.

The body text has been set in 12pt Emilida, a typeface designed by
Lida Lopes Cardozo Kindersley, digitised by ITA Kono Design
and commissioned by Timothy Guy Design for EMI.

Contents

All the illustrations are drawn from the records of the Cardozo Kindersley Workshop.

PAX ET BONVM

The Millennium

We are reaching an anniversary, a point to look backwards
and forwards. This is a reason for a celebration. We need to
do something to commemorate this moment.

Lettercutters are in the business of commemorating and
celebrating. They can immortalise an event in a memorial,
make a monument for a special day, position us in the
universe with a sundial, or remember a life with a headstone.
Each of these will take its shape from the nature of the idea.

For the Millennium lettercutters are asked to carve words in
such things as a sundial in a garden, a bench for a village,
a stele on top of a mountain or a large granite boulder for a
Christian festival.

These letters – in these cases, cut in stone – tell us something of
our time and through them we can assess to where we have
come. Letters are cut in stone so that the words will last.
Amazing things have come to pass in the world and many
possibilities lie ahead of us, some already dreamt of, some not.

Cornish slate, letters painted off-white

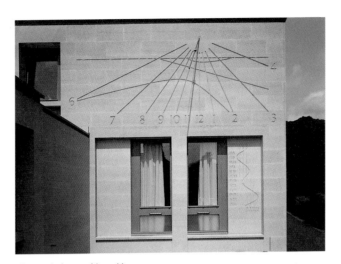

*This sundial was calibrated by
Dr Frank King on the spot after only a
small rough sketch was passed by the
Master and Fellows of Pembroke
College, Cambridge. It was cut in situ.*

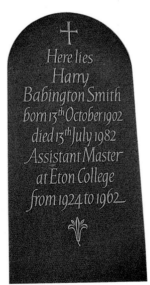

Here lies
Harry
Babington Smith
born 13th October 1902
died 13th July 1982
Assistant Master
at Eton College
from 1924 to 1962

*Green slate headstone at Eton Wick,
Berkshire*

> *a friend to slaves*
> # THOMAS CLARKSON
> *b.Wisbech 1760-1846 d.Playford*

Green slate in Westminster Abbey

The possibilities are endless and a few are uncovered or discovered in every generation. We will never exhaust these ideas. Letters can be cut endlessly and yet the infinite cannot be caught with finite methods. Yet some ideas and inspiration from our times can be left behind cut in stone. These may show where we are and where we think we are going. In our fast changing world we need these reference points; they give us assurance and stability from which we venture forth. We need them more than ever at present, as alienation is now so fashionable and dangerous.

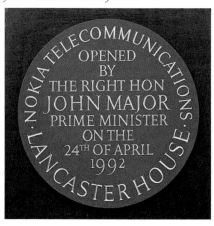

Welsh slate, gilded, in Huntingdon, Cambridgeshire

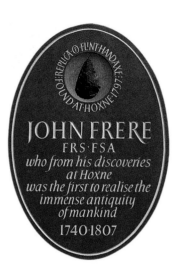

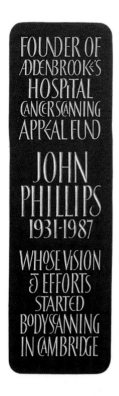

Above: Welsh slate with painted letters and a
replica flint axe, in Finningham Church, Suffolk
Right: Welsh slate, letters painted off-white and
name picked out in gold, in Addenbrooke's
Hospital, Cambridge

Words can shed some light in our world of darkness. Words
cut in stone will outlive us and be part of future generations as
well as part of our own and past generations. However fast
moving, we are still the same people as thousands of years
ago. Our evolution now is in our hands and we need to look
after this by refining ourselves. This can be done with
conviction: we must take full responsibility for our own actions
and not hide behind regulations and machinery. This is
where we need vision, and it is about this that we write.

As we are still the same species as we were many thousands of years ago, our human needs continue and they are there to be recognised and nurtured. There are basic needs – like food, shelter, warmth and so on – but also spiritual needs like a sense of belonging and a sense that what one does is worthwhile. There is also a need for beauty: food for the spirit.

JOHN
LOCKE
1632-1704
WESTMINSTER SCHOLAR
CENSOR OF MORAL PHILOSOPHY
I know there is truth opposite to
falsehood that it may be
found if people will
& is worth the
seeking

Belgian marble in the floor of Christ Church, Oxford

We are made of spirit. The process of creation is spiritual. Education and experience should draw out and encourage development of that spirit and being, so that each person realises his or her vocation. Through pursuing that vocation – with energy, skill, understanding, love, dedication and awareness – a person can refine this spirit and aim for perfection within the achievements of his or her life. Creating beautiful things is one physical realisation of that spirit. Beauty, in turn, can inspire others to reach for high ideals and so become involved in the movement from the visible to the invisible in an upward spiral. It is a necessary vision to encourage and to urge people to work with this essential life force – and so to explore and appreciate the wonder of our existence and the infinite possibilities before us.

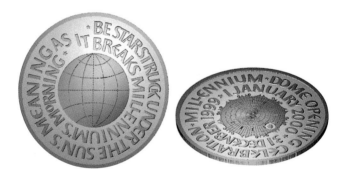

Designed for the Millennium Experience to commemorate the opening of the Dome, 31 December 1999 to 1 January 2000. Poetry by Simon Armitage, inspired by his Millennium Poem for the Dome. Computer generated image of medal designed by Lida.

Preservation

First of all, we will look at the need for stability. This is not static fossilisation, but balance. Beauty looks after herself, as Eric Gill said. People have for ages felt the need to preserve that which they value. This is partly a statement but there is also a need to hand on these testaments to those who will follow and to give a solid foundation from which to work. People are prepared to invest an enormous amount of resources, energy and time towards achieving their goals and leaving something which will speak to contemporary witnesses as well as to future generations.

Portland stone, at Eton College, Berkshire

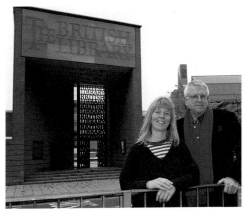

Lida Kindersley and Professor Sir Colin St John Wilson outside the British Library. The letters were cut in situ and the gates were cast by the Morris Singer Foundry.

Buildings are very clear evidence of the living spirit. Experiencing the theatre at Dodona, the city at Ephesus or the Basilica S. Marco in Venice speaks impressively. The sheer physical effort alone is striking enough. All those minute pieces of mosaic in S. Marco were carefully put there by hand, by a society which believed in the value and beauty of the ideals they were expressing. The time that must have been dedicated to the creation of those mosaics is evidence of their intent and is an overpowering marvel in itself. The inspiration of the end result is exhilarating for others; but those who made the mosaics had worthwhile lives. Here we witness a lasting legacy speaking very powerfully across time.

Lettering painted off-white.
Slate box made by Inigo Jones, Wales

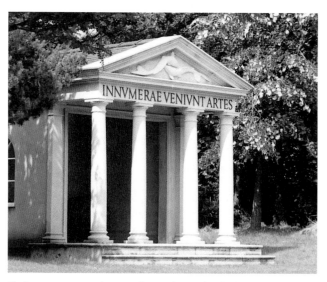

The letters were cut out of MDF and cast in bronze, then fixed to the frieze in situ. The fish were modelled, cast and applied. Saling Hall, Essex

Architecture and lettering in stone share great similarities. Both share the basic principles of living: freedom and discipline, beauty and usefulness. Both share the basic principles of design: proportions and optical illusions. Both are necessities whose activities have several layers of purpose, arranging functional and decorative elements into strong and convincing forms. Both usually make creations out of materials that will last. The results of both activities are utterly and recognisably human creations. They reflect culture and they influence daily lives.

The basic purpose of building is to create a shelter, and to provide safety from physical attacks. The basic purpose of lettercutting is to convey information. But the purposes of both activities far exceed these basics. Both architect and lettercutter aim to arrange all the necessary components into a balanced composition, so that the basic needs are covered; but more than that – to create also a harmonious composition, and one that radiates the ideals and beliefs of the people involved in the creation. Harmony is reassurance; and from this can come stability, excitement and inspiration. This can be achieved quietly or loudly, in conservative or in progressive tone.

Seven feet across, this circle of green slate is set in the floor of a new building at Ampleforth Abbey, Yorkshire

An ideal of architecture (and letterforms) which has endured through many eras is that of Classicism. Originally the language of architecture of the Greeks and the Romans, this ideal has been represented, revisited, re-interpreted, and re-enjoyed many times. The Renaissance embraced the ideal with great fervour; then the Neo-Classical came (partly as a reaction to the florid rhetoric of Baroque); and later that leading voice of Modern Architecture, Le Corbusier, enthused about the character and proportions of Classicism (declaring them of prime importance and use to modern life). Even Wittgenstein's House in Vienna is based on Classical proportions. We are talking about only Western culture. What is the essence of this appeal? What does this illustrate to us?

THIS GALLERY WAS REFURBISHED
THROUGH THE GENEROSITY OF
THE A G LEVENTIS FOUNDATION
AND WAS OPENED BY
HRH THE DUKE OF EDINBURGH KG KT
CHANCELLOR OF THE UNIVERSITY
MDCCCCXCVII

Portland stone, letters painted, in the Fitzwilliam Museum, Cambridge

The repeated return to Classicism illustrates perhaps three important things. First, Classical proportions relate to human proportions. The Golden Mean – embraced enthusiastically by Le Corbusier in his work 'Le Modulor' – is in fact a reflection of the proportions of human measurements. We can relate to

buildings constructed around these harmonious proportions because we share these proportions. Each part relates harmoniously to each other and the whole.

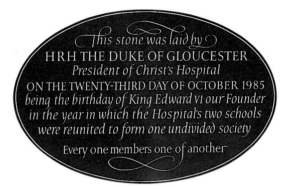

Alberti wrote

'I shall define Beauty to be a harmony of all the parts, in whatsoever subject it appears, fitted together with such proportion and connection, that nothing could be added, diminished or altered but for the worse...'[1]

How wonderful it would be if all humanity related to each other so constructively and peaceably.

Secondly, Classicism speaks with clarity and a visually pleasing vocabulary. Classicism is not only the structures associated with it – the orders, the pilasters, the decorations, the physical components – but also particularly the proportions of these pieces. It is a matter of ratio.

One of the large Portland stone capital Ls was one of the first things cut by David Kindersley when he was apprenticed to Eric Gill

There is order, and there is harmony. Vitruvius wrote
 'Architecture consists of Order... Arrangement... Proportion, Symmetry, Propriety and Economy...' [2]

There is order and harmony in the natural world, and the proportions of nature inherently reflect such patterns. This is one explanation as to why harmony is appealing. Here we touch on mathematics, and the question of repeating ratios and rhythms.

*Life has an unalterable rhythm about it: day follows night,
week follows week, the months follow and make up years.
Each year we can celebrate an anniversary and revisit
familiar ground, but ground slightly altered through time.
There is also the constant rhythm of a heartbeat, an obvious
essential controlling mechanism of our lives. Routine and
discipline are vital to life – there is a sense of knowing where
one is. The division of time into mathematically measurable
units helps us to make sense of time and fit into life.*

*'The word when written
endures'
One of eight Welsh slate
panels, 12 inches square, a
Millennium project for the
University Library in
Cambridge*

*Thirdly, there can indeed be lasting ideals of beauty – ones
which transcend the whims of fashion, partly because of their
innate beauty but also because they are familiar and we can
relate to them and understand them. In short we are
comfortable with them. There is also a rather special quality
and serenity about something that has endured so long, and
has spoken to so many people.*

Ideals do endure, in balance and harmony. What applies to life, applies to architecture and to lettering. This is not to say that only Roman letters should be used – far from it! It is essential to create forms actual to the time, even though they are based on previous letters.

An ingredient of beauty is the harmonious arrangement of elements – in balance within themselves, with each other and in proportion to the whole. There is also the crucial balancing of the different parts of the letter to each other, and the letter spacing.

THIS STONE WAS LAID BY
THE MOST REVD & RT HON GEORGE CAREY
ARCHBISHOP OF CANTERBURY
DURING THE LAMBETH CONFERENCE
22 JULY 1998

Lepine limestone with painted letters, Foundation Stone for Canterbury Cathedral Education Centre.

The inscription must be in proportion to its surroundings as well. All these elements must be arranged in relation to themselves and the whole needs to speak with clarity. Then a beauty will be achieved that will speak to future generations as well as to contemporary witnesses. This process is about refining and creating new forms: creating new interpretations of, and aiming for, perfection. Lettercutters need vision and conviction to aim for this perfection, and the humility to know they will not reach it.

There is a need for things of lasting beauty. Yet we also have a very strong need to change things. The act and significance of making new things are manifold. Whatever we do now changes the meaning of what has been before, and what comes after.

Creation concentrates the mind, captures the imagination, betters the soul and therefore is deeply satisfying. Creation is a way of developing one's beliefs by interpretation. We position ourselves, declare our hand and leave evidence of our state. Creation is vital for spiritual survival. Not making new things is bad, and leads to frustration. There should always be a space for every human being to create – cooking, sewing, gardening, lettercutting, model-making, drawing, writing, music, singing or anything else. Creation must also be an expression of love. One cares about the ideals expressed and the form in which they are expressed. One cares enough to dedicate time and to refine skills for a creation. One hopes a thing well done will encourage those who follow to capture some of the vital spirit to create something themselves, and to love doing so.

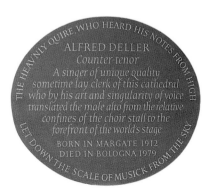

Green slate, in Canterbury Cathedral

Creation

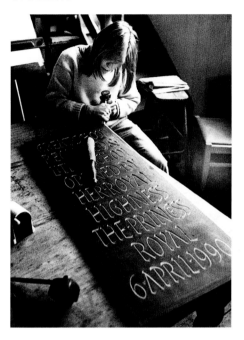

Creativity is a necessity. What we are making may not be a physical object, but it is the act of creation that is symbolic of our existence and spirit. Cutting letters is a very physical act. These letters then radiate a spirit. To cut letters in stone involves the channelling of energy to create something that will inspire. Lettercutters need to use existing letterforms, but add to them their own distinct interpretation, making them appropriate to the age in which they live. Each piece is unique, as we are ourselves.

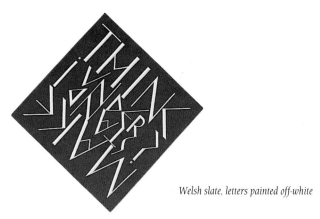

Welsh slate, letters painted off-white

The creation of something by hand speaks with an individual voice. We cannot create this spirit, we can only reflect it. For many ages, people have enjoyed and revelled in that combination of physical, mental and spiritual endeavour that takes place when making something.

manufacture, *man-ū-fakt'yar, v.t.* to make, originally by hand, now usu. by machinery: to produce unintelligently in quantity.

Welsh slate, dictionary quotation, painted letters, cut for the opening exhibition of the Design Centre

Handmade creations speak in a distinctly different tone from those made by machine. Mass production and a fast moving world full of transitory phases are responsible for many things being made for obsolescence. There is little respect for some of these items. Our lives are being increasingly dominated by the

values these represent. Not only are we surrounded by machine-made goods, but also we are often governed and "processed" by machines. There are of course advantages in mechanisation for certain things. It can be efficient, accurate and time-saving, and spare us many tedious and repetitive tasks. Time saved by not having to do these tasks could be used for contemplation, development, creativity or enjoyment of life. But, in themselves, the results of mechanisation and mass production are faceless and anonymous. They make money for some, and unhappiness for many.

A stone, well cut for a clear purpose, done with love and dedication is a time-consuming thing to make. A stone is commissioned because someone feels strongly that they want to commemorate something, or someone, special. To commemorate is to hold as worthy of remembrance; to celebrate; to give it weight, gravitas or importance; to perpetuate. A cut stone is a material thing representing something immaterial - both it and the letters are symbols.

Here
in 1897 at the old
Cavendish Laboratory
J·J·THOMSON
discovered the electron
subsequently recognised as
the first fundamental
particle of physics and
the basis of
chemical bonding
electronics and
computing

Welsh slate, letters painted, in Free School Lane, Cambridge

Stone is one of the world's natural resources. One of the beauties of cutting letters in stone is the material itself. It has been around in its various forms, colours and strengths for millions of years. It is a solid part of the world's history and its creation. It has in it an inherent beauty and stability. This precious natural resource and its history must be respected, and in cutting one wishes to add to it something that aims to enhance the world. Cutting letters in stone fuses the timeless natural beauty and permanence of the material with a living message and meaning. As David Kindersley wrote, 'The main object of cutting words into slate or other hard materials is that they should last.' [3]

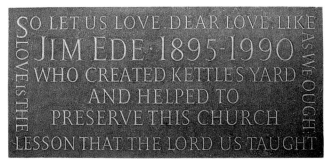

Bird's eye stone in the floor by the altar of St Peter's Church Cambridge, next to Kettle's Yard

'Through our love for letters – for the alphabet, for writing and lettering – we aim for perfection in the transmission of meaning. It is our reason for being.' [4]

To create something that is to last, it must be of value and of the highest quality. This is a responsibility from which lettercutters cannot escape. So they must give everything to achieve excellence.

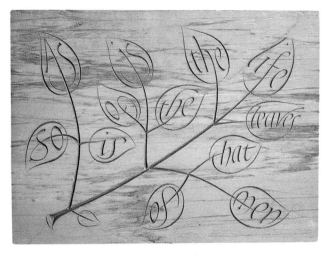

Dove grey marble with painted letters, quotation from Homer

Beauty lifts us above the mundane and daily. It encourages us to see things differently and to contemplate. It speaks with great clarity, and yet exudes mystery. It is clear, but subtle.

Looking at a memorial reminds us that our own life is finite – and perhaps we should assess our purpose and make the very best of the time we have. This might even be a turning point, and encourage us to find our own vocation and to build on our creativity.

Letters and Words

Letters make words. Words are one of the main ways we interpret and understand our world. We act on words. We find our way through words. We pass on knowledge through talking and writing with words. Literacy is a vital link in the web of humanity. Words can be spoken – existing for a moment; or written – so lasting for longer. They can be cut in stone, hence preserved. They can describe something very simple, or extremely complex. They have great power.

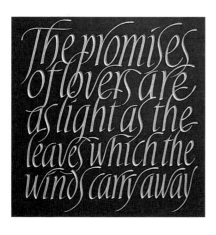

Quotation from Ovid's 'Amores' cut in Welsh slate and gilded, at Glasgow Art Gallery and Museum

Below:
Quotation from Basil Bunting, green slate for the Botanic Garden in Durham

WORDS! Pens are too light
TAKE A CHISEL TO WRITE
BASIL BUNTING 1900-1985

Associations, characteristics and emotions can be conveyed by subtle selection of words, their positioning and style. Letterforms evoke a feeling too. A sans serif face may invoke associations with modernity, a serif face with Classicism and antiquity. The flowing strokes of a letter extended into a flourish may convey elegance and suggest a flowering force, an exuberance and a vivacity.

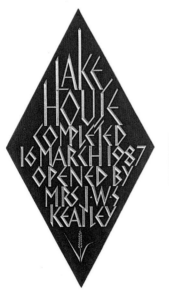

Welsh slate, gilded, at Royston, Hertfordshire

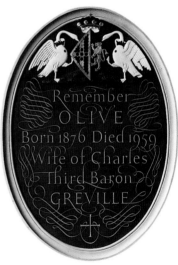

Welsh slate, fully painted and gilded, in South Mymms Church, Hertfordshire

Spacing determines rhythm. Rhythm is an important ingredient of life. It orders life. Words and letters need ordering to be understandable, therefore spacing is vital.

MEMENTOTE CORAM DEO
WILLELMI GEORGII
VRRY
ET HVIVS ECCLESIAE
METROPOLITICAE ET
VRBIS CANTVARIAE
CHARTOPHYLACIS
APVD OXONIENSES
PRAELECTORIS IN
PALAEOGRAPHIA
AVLAE SANCTI
EDMVNDI
1913 SOCII 1981

Welsh slate with letters painted off-white, in the cloisters at Canterbury Cathedral

This Library
was opened on 15 May 1999 by
THE RIGHT HONOURABLE
THE LORD HOWE of ABERAVON CH·QC
on the occasion of the Annual Gathering
of the Trinity Hall Association
in the presence of ALAN GRIEVE
Chairman of the Jerwood
Foundation

Welsh slate, gilded, for the new library at Trinity Hall, Cambridge

The arrangement of words includes also the space between the lines, and the space between the words and the edge of the stone. If words are too far apart, it is more difficult for the eye to comprehend – they do not seem linked. If spaced right, cohesion and a sense of balance make the composition appropriate, pleasing and easy to grasp. Subtle adjustments can alter the meaning and tone considerably. Of course words do not have to be arranged in lines – they can be placed in circles, ovals, triangles, octagons, in any shape or apparently at random to create a vast variety of impacts, soothing or energetically exciting.

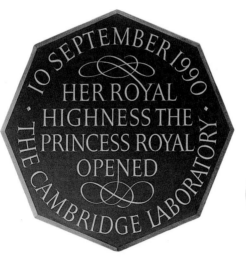

Left: Welsh slate at The Cambridge Laboratory, Norwich
Right: Welsh slate nameplate in Worcester

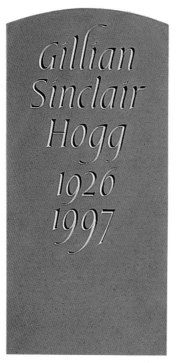

Green slate with painted letters, in
Putney Vale Cemetery, London

Words have a double power to transmit meaning. In one way,
they transmit meaning by their very choice. A few carefully
selected words can often speak more than many. They have
been described as 'like the "still small voice" of the scriptures' [5]
– this was when referring to one memorial which had simply
the name of the person and the years he was born and died.

Once chosen, they have the power of speaking on all sorts of different levels through their forms. As the tone of a voice alters when wishing to convey different meanings so the choice of form, size, combination of shapes and whole arrangement of letters and words will alter according to the feel of the message one wants to convey. Understanding those messages – from the person commissioning the work, and as expressed in the letters and words themselves, is one of the skills of the lettercutter. A lettercutter must be able to listen.

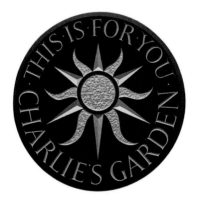

Welsh slate, painted and gilded, in Cambridge

The Idea

The central idea of cutting letters in stone is to make things last. Lettercutters commemorate, shape, develop and refine. Amidst all the daily events in his or her life, the commissioner has the need to concentrate on one thing, to preserve it for posterity and to be jointly responsible with the lettercutter for creating something that will show how that event or life was of particular value, and to celebrate that.

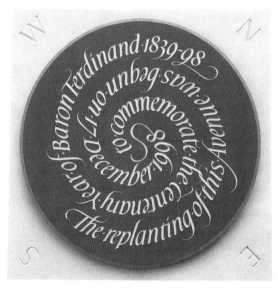

The lettercutter knows the techniques and materials, but must listen to find out what is needed; he or she can then offer an interpretation of what is expressed. This needs imagination, knowledge, understanding and sensitivity to the needs of the

person with the original idea – and humility. Often the best ideas come from the outside and trigger new responses to evolve into an original approach and solution.

The principal idea of cutting letters in stone has parallels with the landscape of everyone's life. From all the infinite number of possibilities before us we must single out one, the right one, focus on it and see it through. Therein lies a role for ourselves, a way of participating in and adding positively to the world. There must be a moment of decision – the incisive moment, which needs bravery, conviction and sensitivity. Before we can play our part, we have to master skills, knowledge and understanding and be ready to offer something of worth.

'There are two sides to a lettercutter's nature – or there ought to be. Just like any other craftsman or artist he will be spending a lot of time making things that he feels should be explored and making other things that people want…The client… knows what he wants and comes to you because he cannot make it. This can be a humbling experience for the artist craftsman who thinks he knows best, but lucky is the artist craftsman who likes his clients and is prepared to listen to them for they guide him along paths that he would never have taken without their help.'[6]

For letters to be cut in stone, there has to be a vital spark: the meeting of the commissioner and the lettercutter. This will ignite the flow of ideas which will then be developed and refined.

The Meeting

At the first meeting, it must be discovered what is needed, for whom and where. Ideas and ideals are shared, so that understanding can develop. This has to be a relationship of trust, so that slowly and deliberately a point of agreement can be reached and there is no drifting apart.

Remember

JACK SIMMONS MERRICKS
Lord of the Manor of Icklesham
Farmer & Sailor
Drowned 13 September 1970
aged 60 years

A man of Earth who knew
How every inch of an acre
Is alive; and what was best
For root and beast, and got it.

He argued as obstinately
For freedom, as the sun does
With the seeds, till they submit.

Be proud
Of a man so placed, so true
To why we are alive.

Solstone painted light red, at Icklesham, East Sussex

'One of the qualities that makes a memorial important is the truth of the feelings that persuaded the client to commission it in the first place. Somehow this degree of truth always comes across to the maker and is in turn reflected in the thing made.'[7]

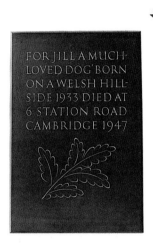

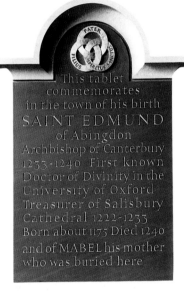

Welsh slate, in Cambridge

Slate with Portland stone capping in St. Nicholas Church, Abingdon

That depth of feeling will be transmitted to the lettercutter who, in turn, will be able to concentrate with even greater energy to create a work which speaks with greater purity, clarity and beauty.

Throughout '...the triangular relationship of material, artist and patron is celebrated by us all, working together from beginning to end; and...as the work develops, so do we.'[8]

The more that is involved, the more complex the process of designing and also the more possibilities there are. The more that is put in, the more will show.

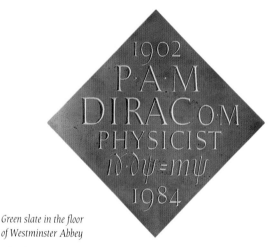

Green slate in the floor of Westminster Abbey

The lettercutter has a sense of service, can experience the important human need of belonging and being useful and can be part of the creation of beauty. In the partnership, the lettercutter also has a sense of responsibility for making the best commemoration possible of something so worthwhile to the commissioner; and this can inspire both parties to great heights. Once the lettercutter knows the motives behind the creation, he or she can share in the responsibility.

JOHN
RUSKIN
1819-1900
GENTLEMAN COMMONER
HONORARY STUDENT
THERE IS NO
WEALTH BUT
LIFE

Belgian marble in the floor of Christ Church, Oxford

Design

'Lettercutters are … able to reproduce any shape of letter…
This fact means that you have an almost terrifying freedom to
abuse or enhance the comprehension of words.' [9]

Welsh slate, letters painted, in St Giles', Oxford

The first discussion between the lettercutter and the
commissioner determines the direction of the design, homing
in on the necessary and the possible. At that point, everything
is possible but after careful consideration the direction becomes
clear and the form follows. Then, whilst sketching, it becomes
more obvious which possibility to follow, as certain approaches
are eliminated.

THE ONLY PERMANENT CONDITION IS CHANGE:

Above: Portland stone, left from the claw tool
Below: Welsh slate, painted off white, translation of the above

For the lettercutter's part, the ability to explore several possible solutions is necessary. This requires knowledge of letterforms and ingenuity in using them, or deciding to create new ones. He or she must have energy and determination to pursue and explore the different ways of arriving at a design solution, and the judgement to know when the right one is reached.

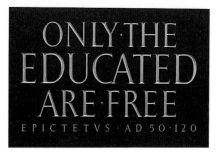

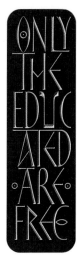

The same quotation treated in two different ways, both Welsh slate with painted letters, the quotation on the left is gilded

The shape of the stone, the shape of the design and the margins, the shape of the words (which includes the spacing of the letters) are all ingredients of an inscription. Spacing is crucial. 'However beautiful your letterforms are, it is the spacing that matters above all else. A beautiful letter is ruined spaced badly. A rotten form well spaced is more tolerable.'[10]

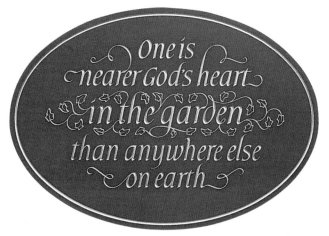

Welsh slate with gilded letters, Sowley House, Hampshire

If one wishes to emphasize a particular word within an inscription there are many possible ways this can be done – it can be on a line of its own; it can be larger; it can be in a different face or italic (if the rest is Roman) or bold. It can be surrounded by flourishes, or accompanied by a symbol such as a cross, a decorative device like a flower, or picked out in a colour or in gold.

45

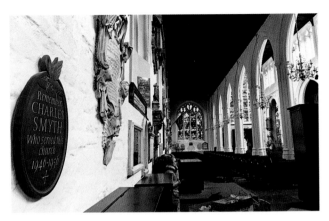

Welsh slate in St Margaret's, Westminster

At the same time, the design must be considered in relation to the work's destination. The inscription must take its place comfortably in either a natural or a humanly created environment. It must speak in the right tone, and demonstrate sensitivity. This introduces the question of light.

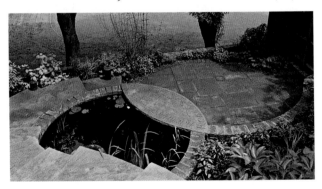

Lettered seat as part of Abigail Concannon's overall garden design

Natural light is always changing. Light inside a building may be artificial and may be made to change as well. Stained glass will alter light dramatically at different stages of the day. The colour of the stone, the shape and size of the letters – the whole design – must be considered in relation to the light by which, and the environment in which, the work will be viewed.

Lettercutters always have the possibility for experimentation and innovation with words and letters. New shapes can be created. New effects can be orchestrated. Shapes and sizes can be mixed – such as putting one letter inside another, placing small letters with larger letters, mixing Roman and italic, linking letters together.

Welsh slate, gilded, nesting letters for Ampleforth Abbey, Yorkshire

All these different combinations will evoke a variety of responses. New idioms can be created – making the letters actual to the time, combining that which is inherited with that which is offered. As a design evolves and changes, so do the people involved in its creation.

Knowledge, experience, skill and feel all play a very significant role in the evolution of a design. Through experimenting, lettercutters push the boundaries. They can use knowledge to adapt that which has existed before, or which they have created before. By doing, they learn and acquire humility through knowing what they are doing wrong and where they are lacking insight. What they create may inspire the commissioner with another idea and so other avenues are explored which would not otherwise have been considered. Lettercutters must always aim for the highest and have perfection in mind. They must have resourcefulness, energy, organisation and flair to pursue the possible routes to achieve this.

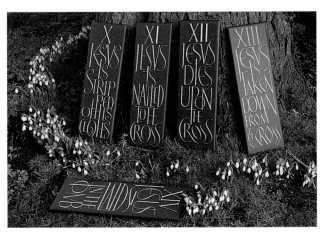

A few of the fourteen Stations of the Cross for The London Oratory School, Welsh slate painted and gilded

The Sketch

At this stage of the design, there is direction in the
lettercutters' understanding but still there is fluidity. There is
as yet no cutting, no finality. They can search the possibilities
and these can develop, evolve and change – freely. 'The best
designs have an air of inevitability about them which
completely conceals the toil that went into their creation.' [11]
However 'toil' disguises the pleasure and sense of quest
involved in aiming for perfection.

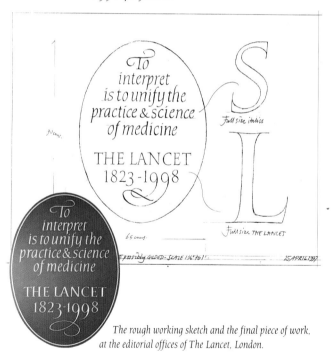

The rough working sketch and the final piece of work,
at the editorial offices of The Lancet, London.

The meeting has taken place. There is understanding. The lettercutters know their business – now they must show where they are. This is the reason for the sketch.

They go to the drawing board and get down on paper the information needed and find the inevitable shape – the right shape for the commissioner, the material and the surroundings.

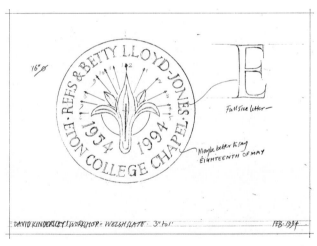

The first sketch for a horizontal sundial

They must back their judgement and all that this encompasses.
They put this down as they see it in their mind's eye and when
they have put it down it can be shared, and altered if points
have been missed or misunderstood. Slowly it develops. The
sketch is kept small so they still leave all detail to be shaped at
the right time, the moment of cutting. One full-size letter on
the sketch gives the letter form and weight. This sketch is the
first step to show the overall design, the shape of the stone or

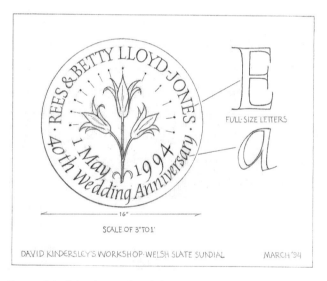

The second sketch for a horizontal sundial.
The final design was for a vertical sundial.

slate, the use of different letterforms and sizes, the spelling and other elements like heraldry or symbols. Each step has its own use, its own place and solves its own problems. It is sad and destructive to attempt to solve all problems at the beginning. Little by little, and each at its own time and place, more solutions and possibilities emerge. The sketch is a design moment and this will lead to the making moment, the incisive moment.

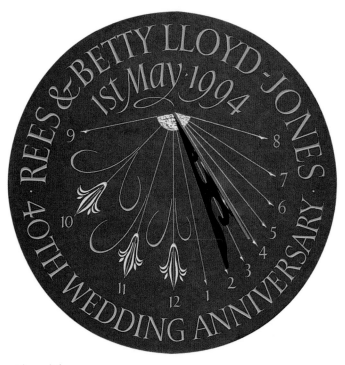

The sundial

The Making

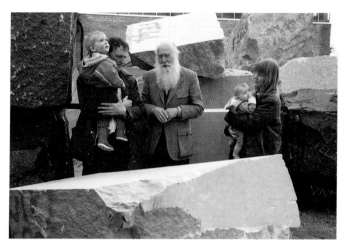

David and Lida choosing a piece of stone

Before the lettercutting can begin, the stone must be prepared. The process of preparation is an act of refinement in itself. First, the stone has to be quarried and broken away from its age old foundations. Then, using a pitch, the big pieces are taken off. After that, a point removes smaller pieces, a claw shapes it, a chisel cuts the surface finer and sandpapers – from coarse to progressively finer – smooth the surface until it is finely rubbed. Something natural is being made into something human.

*For sketching on slate a white pencil is used:
no rulers or full size-drawings are used.
The letterform is in the lettercutter's head.*

*Setting the design out from a scale drawing on to a full size
piece of stone with its variations in weight, colour and shape
means that the design may need subtle adjustments. This
involves, again, moving things until an overall balance is
achieved. After this stage, it is wonderful for the
commissioner to come and see – to check and approve. This is
the last opportunity to move things before they are cut and
held in place for ever. This is the last point before the cutting
that the commissioner and lettercutter meet.*

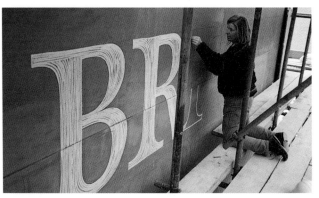

*Big letters are also drawn with a pencil. Here Lida is 'filling in' the letters so they
show up from a distance, so the architect can see and approve them. Only a small
sketch was previously given.*

Cutting is a solitary activity. The design will have been drawn on to the stone and the lettercutter will then cut a three-dimensional letter from that two-dimensional design. The shape must be in their head, a vision, because they cannot work towards a goal if they do not know what that creation is to be. But those letters will not exist until they are cut with the blow of conviction.

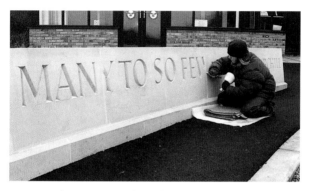

Cutting is a solitary action, even though the Workshop works together

The act of cutting is the lettercutters' incisive moment of meditation and concentration. Lettercutters must be disciplined, totally focused, attentive, precise and concentrated. They must give their complete being – body, mind and spirit – to creation. There are no re-tries at this stage. This is the point of commitment where the hand is declared. They lay themselves open for all to see – they cannot be cowards and they must be perfectionists.

Cutting is a supremely focused activity. It should take place in a quiet and calm environment. The Workshop must be such an environment. However, for work out of the Workshop the lettercutters have to create their own calm. Once a cut is made, it is there for ever for the world to witness. The lettercutters cannot stand by it and defend it for the rest of its life, so it has to speak for itself.

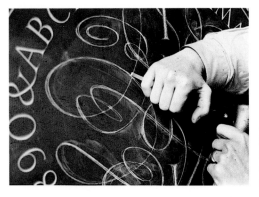

Lettercutters have to create their own calm to know where to go

Lettercutters have to understand the material and its behaviour under the chisel. However, the technique of cutting is the start not the end. The basic technique can be mastered comparatively quickly. Technically shaping a letter does not necessarily make a beautiful letter – it is the first vital step but it needs mental development and "feel". The "feel" of what is right is as mysterious and as elusive as the ultimate creator; but the intuition as to what is right and which radiates the truth is as intensely strong and convincing to those who listen, look and know.

If lettercutters are dull in spirit, or distracted, or their motives are distorted, the letters will be affected. If verve, vigour and spirit were present at the time of making – this will show.

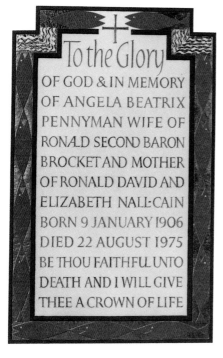

To the Glory
OF GOD & IN MEMORY
OF ANGELA BEATRIX
PENNYMAN WIFE OF
RONALD SECOND BARON
BROCKET AND MOTHER
OF RONALD DAVID AND
ELIZABETH NALL-CAIN
BORN 9 JANUARY 1906
DIED 22 AUGUST 1975
BE THOU FAITHFUL UNTO
DEATH AND I WILL GIVE
THEE A CROWN OF LIFE

Sicilian marble, painted and platinum-leafed, in Lemsford Church, Hertfordshire

Colour is important in the work. The letters are created by cutting, but also will be highlighted by chiaroscuro (the contrast between the dark of the slate, and the light of the cut slate). So sensitivity to colour and shape are also vital skills for lettercutters.

The combination of off-white cutting and grey slate has a certain purity about it. It is subtle, as is the green and off-white of Cumberland slate. This slate has its own patterns and veins, predetermined and unpredictable. Often the letters are painted in the colour of a freshly cut slate, and sometimes other colours are used – terracotta or gold for instance.

Skill is needed in judging when colour will be successful either as a contrast or perhaps because of its significance. For instance, gold has many associations: it is pure, precious, durable, brilliant, rich and joyful.

Welsh slate, gilded, on Stationers' Hall, London

In life, there must be design; and there must be guidance too, good teachers, people to look up to, fertile learning ground and encouragement. To create something worthwhile one needs to have a real "feel" as well as technical perfection in that skill.

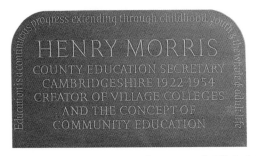

Green slate for the Henry Morris Memorial Trust, on Castle Hill, Cambridge

Fixing

The moment of fixing the work in the place for which it has been destined is an uplifting one. It is the moment of completion – and one of joy and revelation, seeing the work where it belongs. It will be a moment when all the care, love, dedication and knowledge and precision that has contributed to the work will show. Feelings that have been generated have been translated into a physical creation which is evidence of the spirit behind it all.

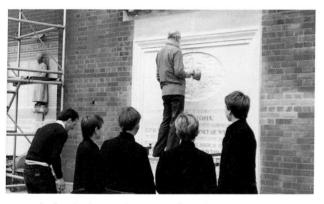

Fixing is hard work. This is at Christ's Hospital, Horsham

If all the elements are taken into account, the whole thing will look right and will be recognised as such. One is seeing to the essence: the possibilities, the value, the wonder of our existence. One is looking in a focused but contemplative way with care, respect and gratitude. Spiritual or positive energy has been harnessed, held and given out.

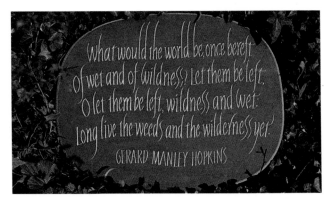

Welsh slate with gilded letters at the Botanic Garden in Edinburgh

The work's full being comes into its own in its surroundings. It conveys a message that however much we may be responsible for our own creativity, there is a force far greater than ourselves which is behind that creativity and is responsible for the completion of our creativity. Equally there is something reassuring and beautiful about slate or stone outside: whatever the light or weather, it – and the statement it displays – will remain as lasting evidence of all that contributed to its creation. This one thing of beauty sheds a little light in a sea of mystery.

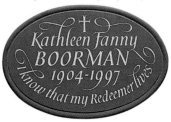

Welsh slate, letters painted off-white
Great Shelford, Cambridgeshire

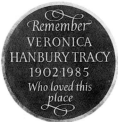

Welsh slate, letters painted off-white
Notgrove, Hampshire

Handing On

*Something intended to last and to speak to future generations
with new energy needs to be kept alive and handed on.
Something essential to those responsible for its creation, made
with love, attention, experience and the knowledge of the time
is being handed on. But also many cultural messages and
words that are unspoken as well as carved in stone are
passed on.*

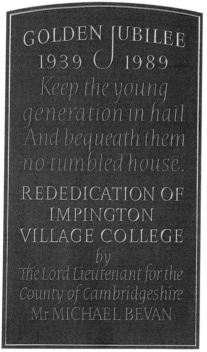

*Welsh slate, painted
and gilded, at
Impington Village
College, Cambridge,
which was started by
Henry Morris in
buildings designed by
Walter Gropius*

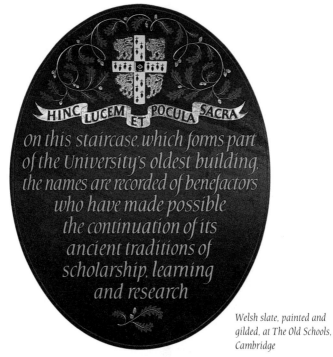

HINC LUCEM ET POCULA SACRA

on this staircase, which forms part
of the University's oldest building,
the names are recorded of benefactors
who have made possible
the continuation of its
ancient traditions of
scholarship, learning
and research

Welsh slate, painted and gilded, at The Old Schools, Cambridge

As we have seen, there is a strong similarity between the creations of architecture and letters in stone. There are three more messages connected with the question of refining. First, the joy of vocation radiates out. Lettercutting is such an absorbing and creative life that this spirit will radiate from the work. Secondly, to create something lasting is itself of value. Thirdly, the commemoration of things achieved highlights the importance of finding one's own role and of making something of one's own life.

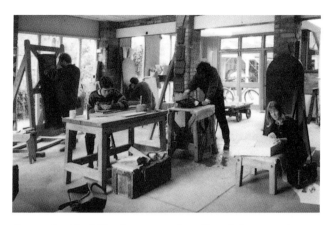

For a valuable skill to be preserved and handed on, people have to be trained to continue this skill. Training in the Workshop is vital. It is good to be a lettercutter, we do not want the understanding and skill to die, so it needs to be passed on. Apprentices are taken on for three years to learn within the fertile Workshop environment.

Apprentice piece by Lida on Hopton Wood stone, straight from the Gill tradition. Every apprentice has to do a first alphabet.

The first months are spent concentrating on letterforms, then on stone itself (cutting and rubbing), and then drawing the letters on to the stone. This is watched closely and there is continuous guidance (draw, and draw again) until it is cutting time. Everything done at any time in stone needs to be the best that can be done – so the first alphabet will be cut by the apprentice and corrected by the teacher. It is a slow process of example and action into an upward spiral of learning and appreciation. Time is of no consequence when learning. Stone is a slow business and, to start off with, even slower than humanly imaginable. This is a problem – not insurmountable – in our fast moving world.

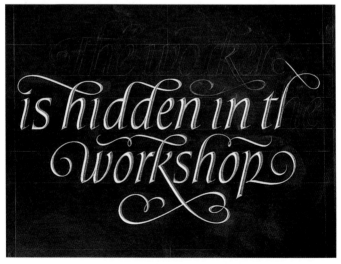

Cutting in progress for David Kindersley's ledger stone

*In this rushed and mechanised age, cutting letters in stone
also cries out against the anonymity, the facelessness, the
soulless and the often irreverent character of much of our era.
It cries out also against the transitory. It is technically
possible and so easy to make memorials mechanically, but this
misses the point.*

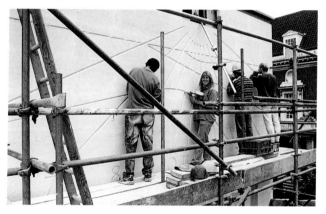

The Workshop cutting the sundial at Pembroke College, Cambridge

*Something considered to be of value must be handed on.
The Workshop keeps alive a skill and way of being that has
long existed because it is a worthwhile life. By example, it
urges people to be creative in their lives. We can control much,
but we cannot create energy and spirit and we cannot control
when life is taken away – that remains a mystery beyond us.
But we can preserve, re-create, appreciate and celebrate that
which we value. Lettercutters hand on many messages,
physical and spiritual.*

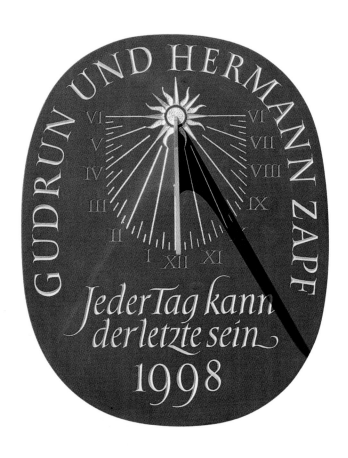

Welsh slate, painted and gilded, at Darmstadt, Germany

Conclusion

So what can lettercutting and the understanding of it offer to the new Millennium? It can offer many things of value. Its focus, clarity and sense of purpose can be an example for many other activities. Its beauty can inspire, and transform. It can encourage us to see properly, and then appreciate the world, life, lives and their possibilities. It commemorates in words the significance of places, lives, events and sentiments.

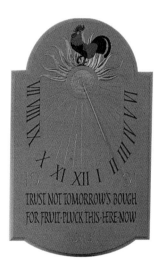

Above: the Maundy Stone in Belgian marble from Wells Cathedral
Right: Sundial in Lepine limestone, painted and gilded, near Toulouse, France
Below: Welsh slate, painted and gilded, in Addenbrooke's Hospital, Cambridge

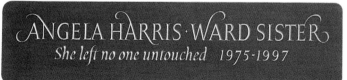

It is a vision to encourage us to look beyond the physical, to value the spiritual, the special and the sacred and to create a role for ourselves in this world. The sense of belonging and doing something worthwhile is vital.

Creating beauty is sacred, mysterious but energetically exciting and inspirational. If you live your life in the service of beauty, then you need an environment of quiet, stillness and contemplation. We then learn to carry this stillness in ourselves wherever we are. To evolve towards this we need strength, and courage.

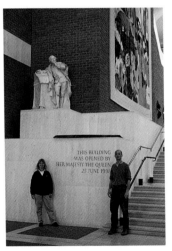

IN THIS PLACE
HALLOWED BY
THE MARTYRDOM
OF
THOMAS BECKET
29 DECEMBER
1170
POPE JOHN PAUL II
AND
ROBERT RUNCIE
ARCHBISHOP OF
CANTERBURY
KNELT TOGETHER
IN PRAYER
29 MAY 1982

Left: Lida and Helmut Hochrein by the opening inscription on Travertine marble in the British Library entrance hall
Right: Hopton wood stone with painted letters, in Canterbury Cathedral

To find the spirit, one needs a vision and a vocation. Everyone has a role. The important thing is to find it: in one's beliefs, activities and relationships as well. Everyone should be able to find a way in which to make a difference to the world and one hopes that everyone can find a purpose to make life worthwhile – and enjoyable.

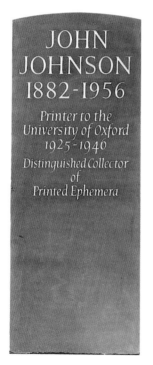
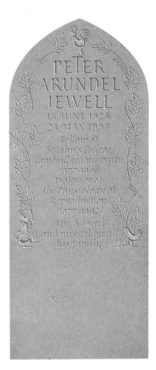

Left: Welsh slate headstone, Headington Cemetery, Oxfordshire
Right: Portland stone headstone, Fen Ditton, Cambridgeshire

Taking the beautiful stone from its source and respectfully adding a valuable message aims to enhance and enrich a corner of the world. A positive occupation gives energy, a life fulfilled radiates joy and, one hopes, inspiration. Creativity inspires creativity.

We have seen that the process of lettercutting involves many facets of activity, sensitivity and understanding. All require feeling and perception. Communication with the commissioner requires understanding, respect for and appreciation of the aims and desires of that person. Design requires creative and intellectual skills. The use of the cutting tools requires physical skills. The whole combines to create a spiritual result, inviting a spiritual response. Careful attention to every detail will show love of adding beauty to this world. New things are realised in the making, and this should be recognised with humility. As stone is shaped, so those involved are shaped and developed. As lettercutters are aiming for perfection, there will always be a next step.

Preservation and creativity are life forces. Having something worthy of commemoration, something sacred, is of enormous value. Leaving things of value is vital too. Appreciating things of value is essential for the enriching and continuation of life.

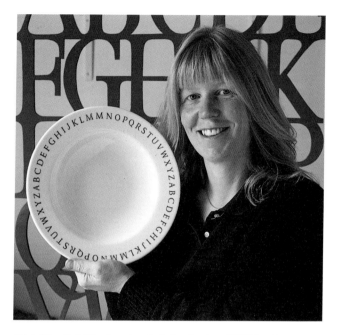

Lida holding the Millennium plate she designed, using gold 'MM' as Roman numerals for 2000

Hopton Wood stone ashtray

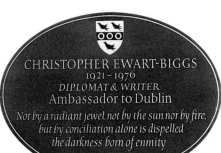

CHRISTOPHER EWART-BIGGS
1921 – 1976
DIPLOMAT & WRITER
Ambassador to Dublin

Not by a radiant jewel,not by the sun nor by fire,
but by conciliation alone is dispelled
the darkness born of enmity

Welsh slate, painted and gilded, in Norton Church, Hereford and Worcester

Commemoration, celebration and reconciliation are words one would wish wholeheartedly to be taking into this Millennium – a celebration of things worth remembering. Remember also David Kindersley's celebration of the triangle of material, commissioner and lettercutter – the celebration of a joint creation, a team working together to create something beautiful to give hope for the future. It is important also to remember people whose lives have been cut short.

1940-1945
Hun plaats bleef leeg·Hun werk onvoltooid

HERMANN EMANUEL· RICHARD GREIF
ALEX KNORRINGA · JOSEPH NIHOM
DRS W·JONGEJAN · *leraar Duits*

Vergeten is ballingschap
Gedenken is verlossing

Welsh slate painted off-white at Utrecht, The Netherlands

We looked at how we should respect the world and its resources, such as stone. However, respect also means to pay attention, to consider, to value with regard or honour. Reverence can imply acknowledgement of a divine or sacred being, something beyond ourselves which is responsible for our birth, being and death – in fact, our spirit.

In this rushed and mechanised age, our own creativity must not be taken away from us. So often we are presented with a fait accompli. People must be thrown back on their own resources. In this often ugly world, beauty can speak with greater force – by contrast. Chiaroscuro (the contrast between dark and light) shows up the light. Also, in this rushed age life can become like an unpunctuated and breathless sentence. A lack of understanding results through haphazardly arranged words and a barrage of information. Pausing and contemplating can help us make sense of life. It is important to stand back and be still.

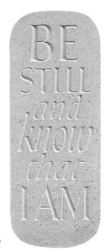

Portland stone in Ireland

One of the purposes of lettercutters is to create something of lasting value and beauty. The example of a task carefully carried out exudes a beauty of its own. Inspired by letters, motivated and excited by their power, beauty and possibilities to master a skill and to use the elements and materials of that skill to create something of lasting value is an example to offer to everyone approaching the Millennium. One hopes that they may find their own vocation, and indeed feel dedicated, determined and inspired with motivation and the possibilities ahead of them.

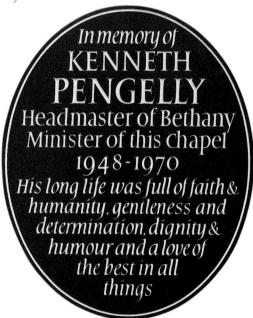

In memory of
KENNETH
PENGELLY
Headmaster of Bethany
Minister of this Chapel
1948-1970
His long life was full of faith &
humanity, gentleness and
determination, dignity &
humour and a love of
the best in all
things

Welsh slate, letters painted off-white, at Bethany School, London

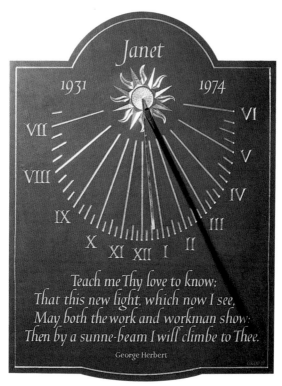

Welsh slate sundial, painted and gilded, Over Haddon, Derbyshire

The creation of something beautiful can inspire others, touch and refresh their souls, open their eyes to some truth perhaps already known or perhaps just perceived. This is a transforming influence in life; one recognised throughout the ages. Beauty created reminds us of the ultimate beauty. To appreciate and offer this as we reach the new Millennium is indeed a transmission of meaning.

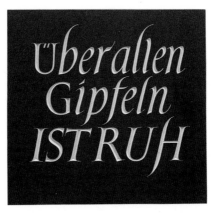

Quotation from Goethe. Welsh slate letters painted off-white

References

1. Alberti, De re aedificatoria, V I, 2
2. Vitruvius, De Architectura I, ii, I
3. David Kindersley & Lida Lopes Cardozo, Letters Slate Cut, publ. 1990, Cardozo Kindersley Editions
4. Lida Lopes Cardozo, The Cardozo Kindersley Workshop, publ. 1999, Cardozo Kindersley Editions
5. Quoted in Montague Shaw, David Kindersley, His Work & Workshop, publ. 1989, Cardozo Kindersley Editions
6. David Kindersley quoted in his 'Personal Note' in Montague Shaw's David Kindersley, His Work & Workshop, publ. 1989, Cardozo Kindersley Editions
7. Montague Shaw, David Kindersley, His Work & Workshop, publ. 1989, Cardozo Kindersley Editions
8. Lida Lopes Cardozo, The Cardozo Kindersley Workshop, publ. 1999, Cardozo Kindersley Editions
9. David Kindersley & Lida Lopes Cardozo, Letters Slate Cut, publ. 1990, Cardozo Kindersley Editions
10. Lida Lopes Cardozo, quoted in Rosemary Sassoon, The Practical Guide to Lettering & Applied Calligraphy, publ. 1985, Thames & Hudson
11. Montague Shaw, David Kindersley, His Work & Workshop, publ. 1989,